Glory of Creation

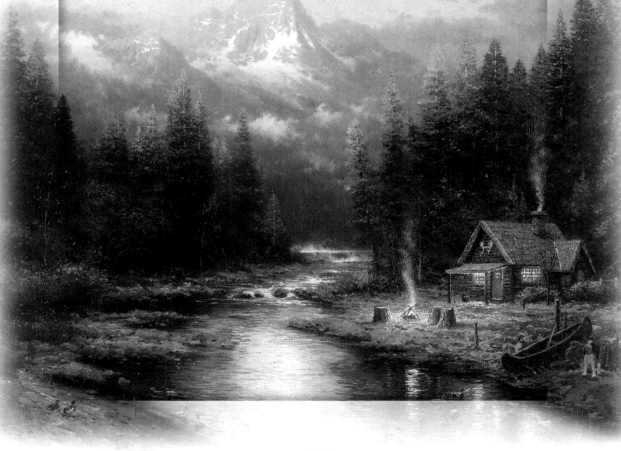

Thomas Kinkade

HARVEST HOUSE PUBLISHERS
EUGENE, OREGON 97402

Glory of Creation

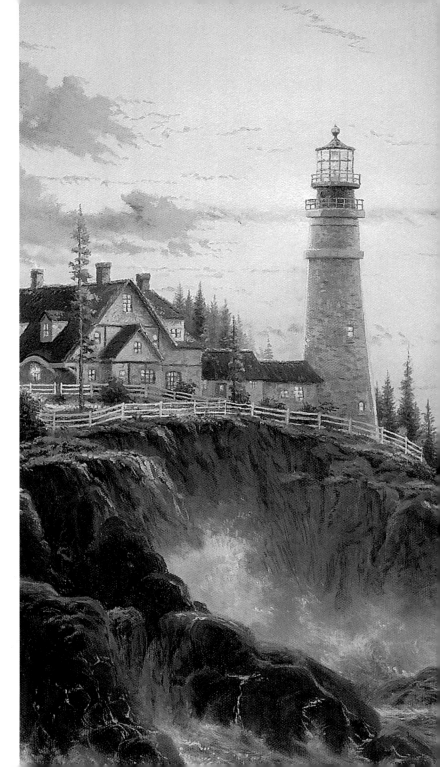

The world

is charged with

the grandeur

of God.

GERARD MANLEY HOPKINS

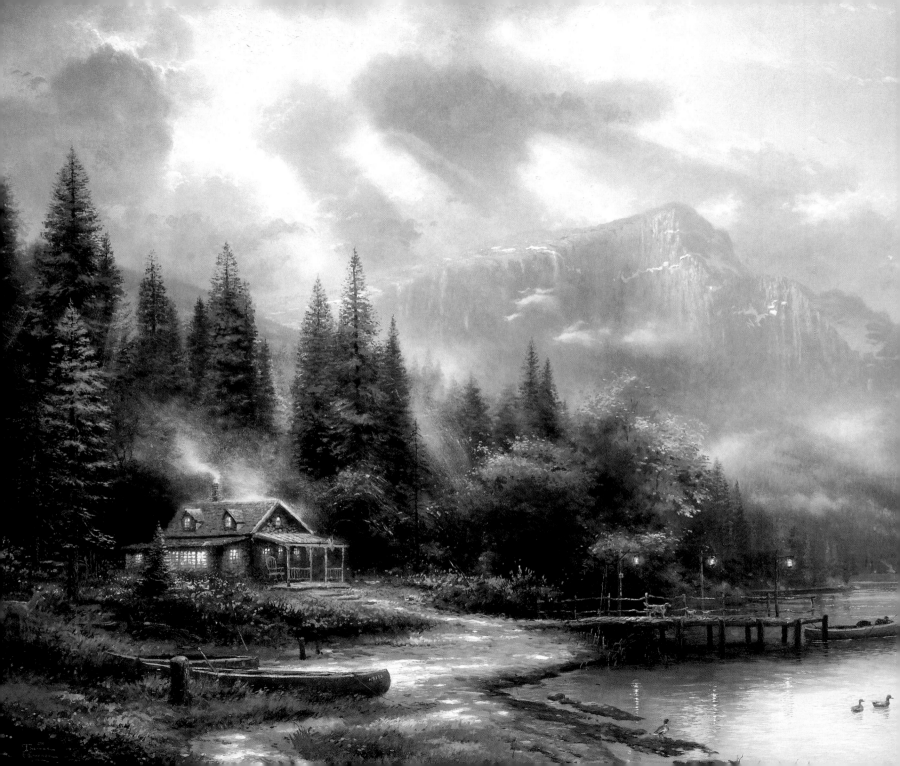

A presence that disturbs me with the joy

 Of elevated thoughts; a sense sublime

Of something far more deeply interfused,

Whose dwelling is the light of setting suns,

 And the round ocean and the living air,

 And the blue sky, and in the mind of man;

A motion and a spirit, that impels

 All thinking things, all objects of thought,

And rolls through all things. Therefore am I still

 A lover of meadows and the woods,

And mountains; and of all that we behold

 From this green earth; of all the mighty world

Of eye, and ear—both what they half create,

 And what perceive; well pleased to recognise

 In nature and the language of the sense,

 The anchor of my purest thoughts, the nurse,

The guide, the guardian of my heart, and soul

 Of all my moral being.

joy

light

spirit

purest

thoughts

heart

soul

WILLIAM WORDSWORTH
from Tintern Abbey

I wandered lonely as a cloud

That floats on high o'er vales and hills,

When all at once I saw a crowd,

A host, of golden daffodils;

Beside the lake, beneath the trees,

Fluttering and dancing in the breeze.

Continuous as the stars that shine

And twinkle on the milky way,

They stretched in never-ending line

Along the margin of a bay:

Ten thousand saw I at a glance,

Tossing their heads in sprightly dance.

The waves beside them danced; but they

Out-did the sparkling waves in glee:

A poet could not but be gay

In such a jocund company:

I gazed—and gazed—but little thought

What wealth the show to me had brought:

For oft, when on my couch I lie

In vacant or in pensive mood,

They flash upon that inward eye

Which is the bliss of solitude;

And then my heart with pleasure fills,

And dances with the daffodils.

WILLIAM WORDSWORTH
I Wandered Lonely as a Cloud

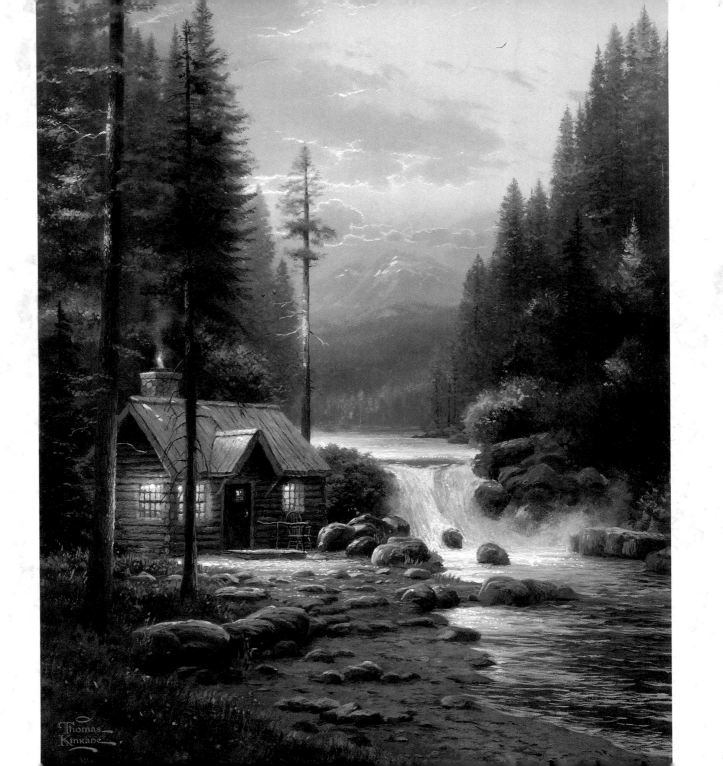

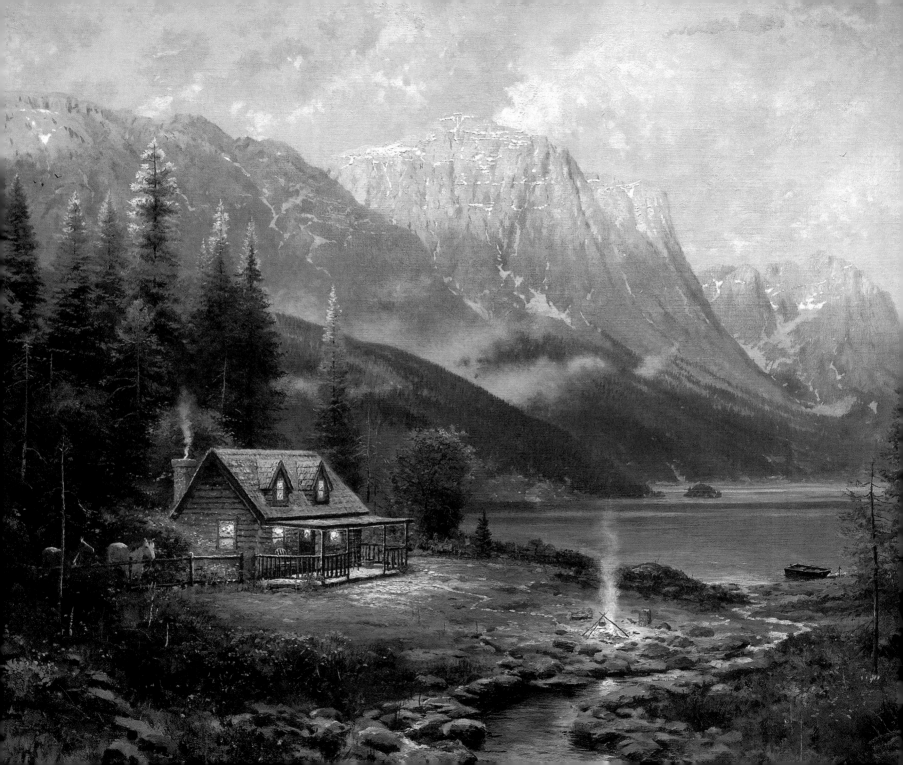

Think for a moment what would be our idea of greatness,

of God, of infinitude, of aspiration, if, instead of a blue,

far withdrawn, light-spangled firmament,

we were born and reared under a flat white ceiling!

I would not be supposed to depreciate the labours of science,

but I say its discoveries are unspeakably less precious than

the merest gifts of Nature, those which,

from morning to night,

we take unthinking from her hands.

GEORGE MACDONALD
Unspoken Sermons, Series 2

To be refreshed by a morning walk or an evening saunter…to be thrilled by the stars at night;

to be elated over a bird's nest or a wild flower in spring—

these are some of the rewards of the simple life.

JOHN BURROUGHS

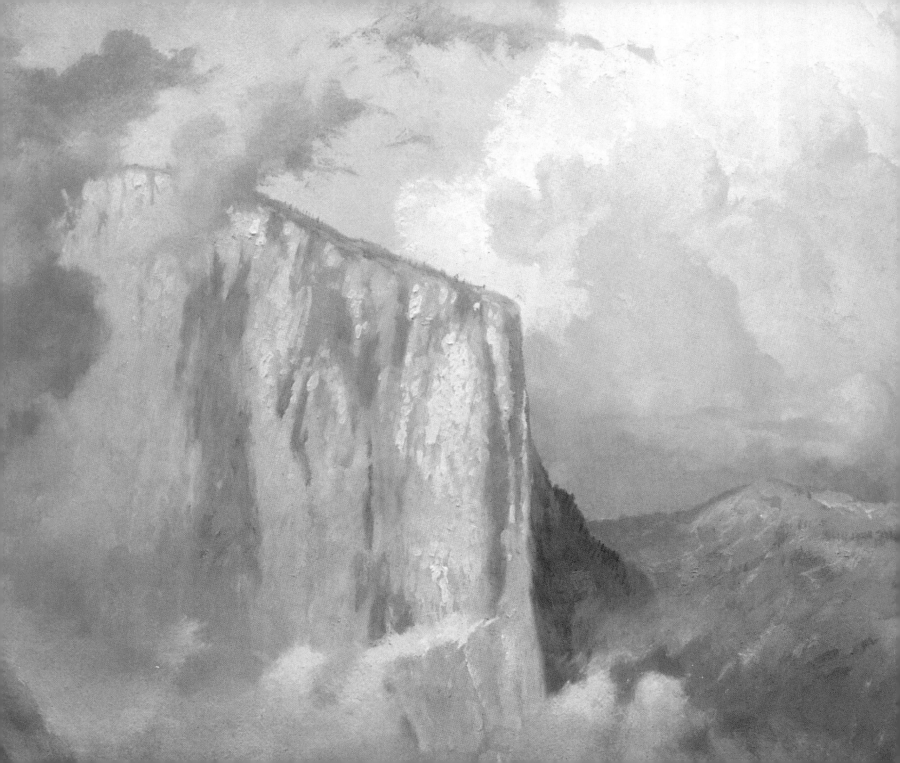

He lay gazing up into the depth of the sky, rendered deeper and bluer by the masses of white cloud that hung almost motionless below it until he felt a kind of bodily fear lest he should fall off the face of the round earth into the abyss. A gentle wind, laden with pine odors from the heated trees behind him, flapped its light wing in his face: the humanity of the world smote his heart; the great sky towered up over him, and its divinity entered his soul; a strange longing after something "he knew not nor could name" awoke within him....

...There must be truth in the scent of that pinewood: someone must mean it. There must be a glory in those heavens that depends not upon our imagination: some power greater than they must dwell in them. Some spirit must move in that wind that haunts us with a kind of human sorrow; some soul must look up to us from the eye of that flower.

George MacDonald
Robert Falconer

This stream floweth dimpling and laughing down

to the great sea which it knoweth not,

yet it doth not fret because the future is hidden;

and it were doubtless wise in us to accept the mysteries of life

as cheerfully and go forward with a merry heart,

considering that we know enough to make us happy

and keep us honest for today. A man should be well content

if he can see so far ahead of him as the next bend in the stream.

What lies beyond let him trust in the hand of God.

HENRY VAN DYKE

He alone stretches out the heavens and treads on the waves of the sea.

He is the Maker of the Bear and Orion, the Pleiades and the constellations of the south.

He performs wonders that cannot be fathomed, miracles that cannot be numbered.

THE BOOK OF JOB

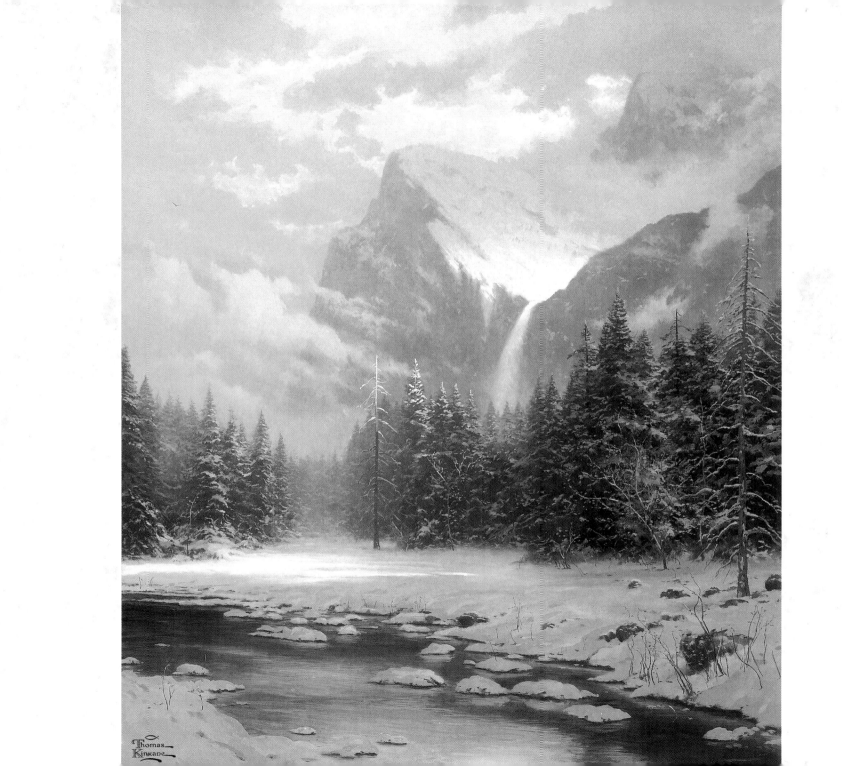

Great, wide, beautiful, wonderful World,

With the wonderful water around you curled,

And the wonderful grass upon your breast,

World, you are beautifully dressed.

beautiful

wonderful

The wonderful air is over me,

And the wonderful wind is shaking the tree—

It walks on the water, and whirls the mills,

And talks to itself on the top of the hills.

friendly

You friendly Earth, how far do you go,

With the wheat fields that nod and the rivers that flow;

What cities and gardens and cliffs and isles,

And the people upon you for thousands of miles?

people

Ah! You are so great, and I am so small

I hardly can think of you, World, at all....

WILLIAM BRIGHTY RANDS
The Wonderful World

so great

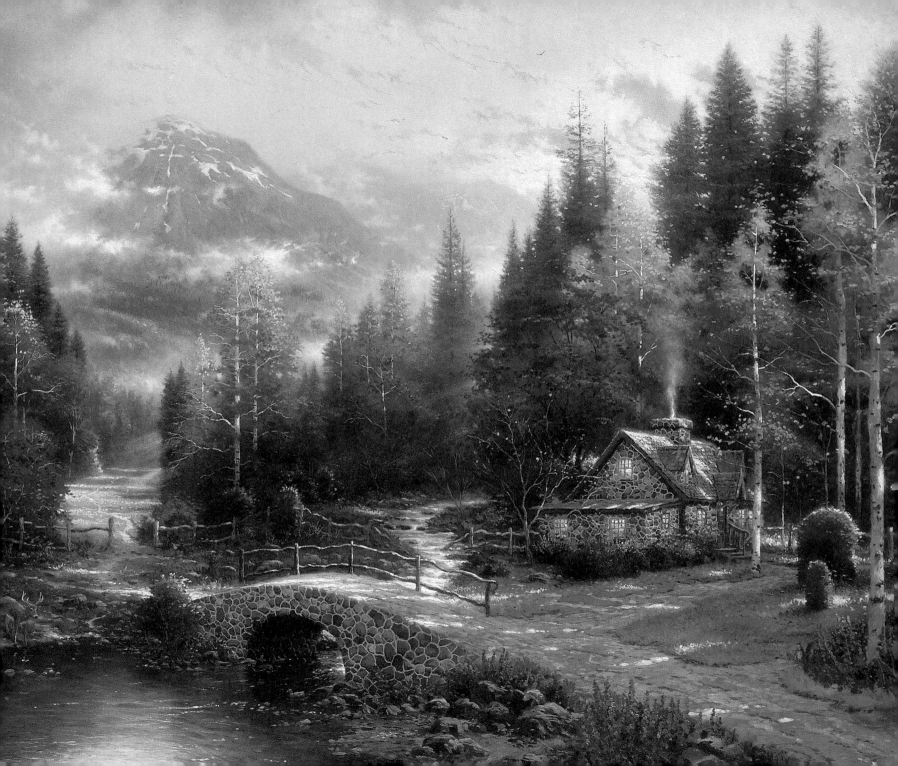

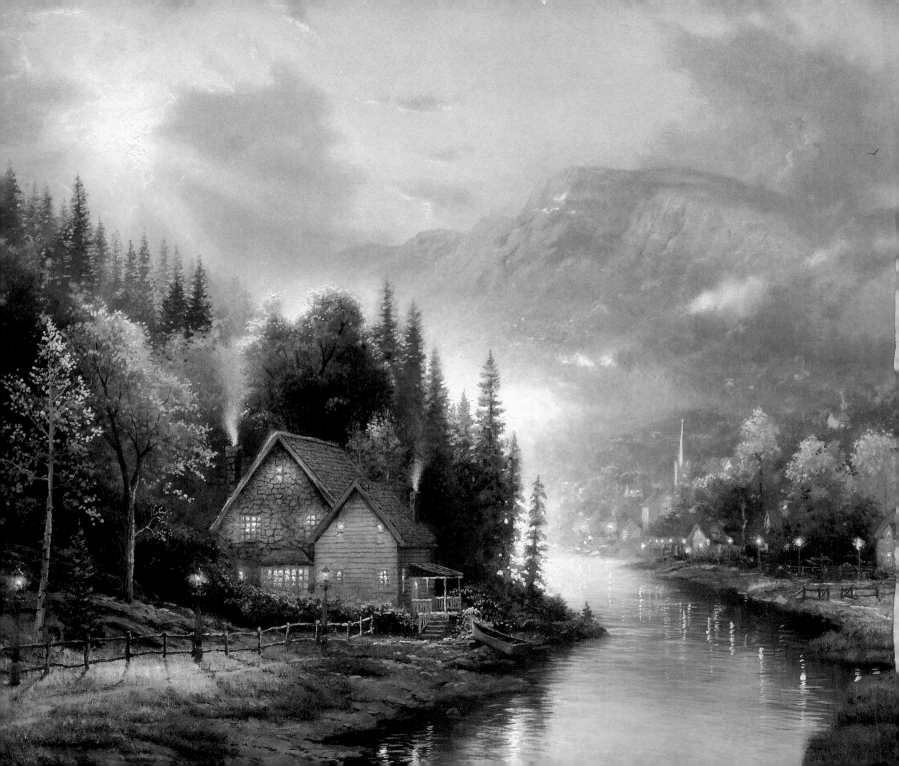

The wood I walk in on this mild May day, with the young yellow-brown foliage

wood

of the oaks between me and the blue sky, the white star-flowers and the blue-eyed

speedwell and the ground ivy at my feet—what grove of tropic palms, what

blossoms

strange ferns or splendid broad-petalled blossoms, could ever thrill such

deep and delicate fibres within me as this home-scene? These familiar flowers,

delicate

these well-remembered bird-notes, this sky with its fitful brightness,

these furrowed and grassy fields, each with a sort of personality given to it by the

imagination

capricious hedgerows—such things as these are the mother tongue of our imagination,

the language that is laden with all the subtle inextricable associations the fleeting

hours of our childhood left behind them. Our delight in the sunshine on the

deep-bladed grass today might be no more than the faint perception of wearied souls

souls

if it were not for the sunshine and the grass in the far-off years

which still live in us and transform our perception into love.

GEORGE ELIOT
The Mill on the Floss

into love

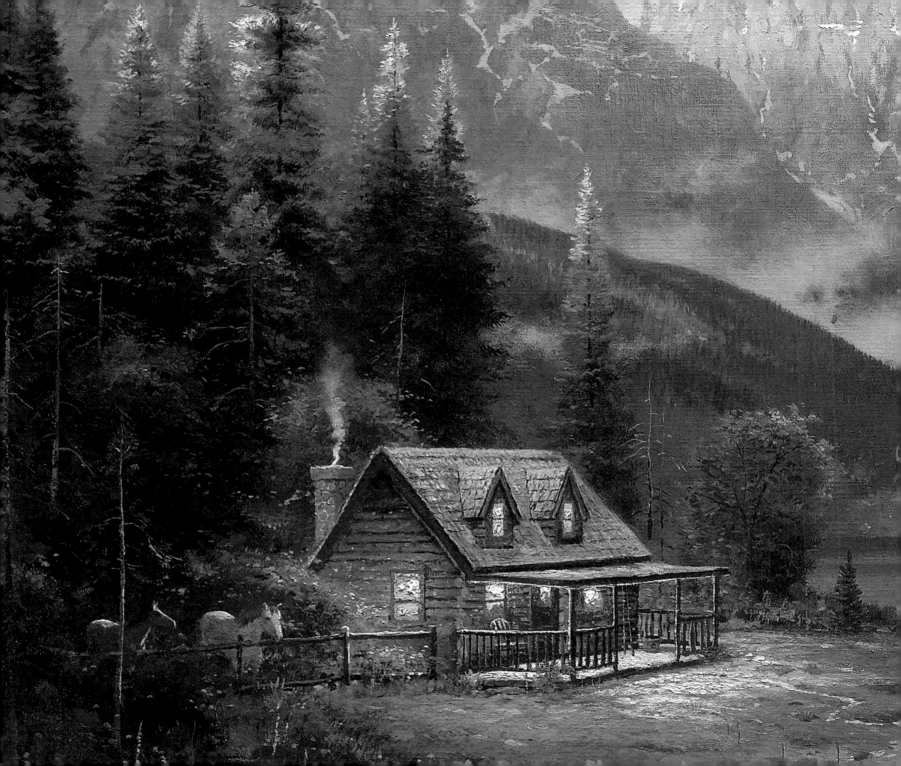

There is a pleasure in the pathless woods,

There is a rapture on the lonely shore,

There is society where none intrudes,

By the deep sea and music in its roar.

LORD BYRON

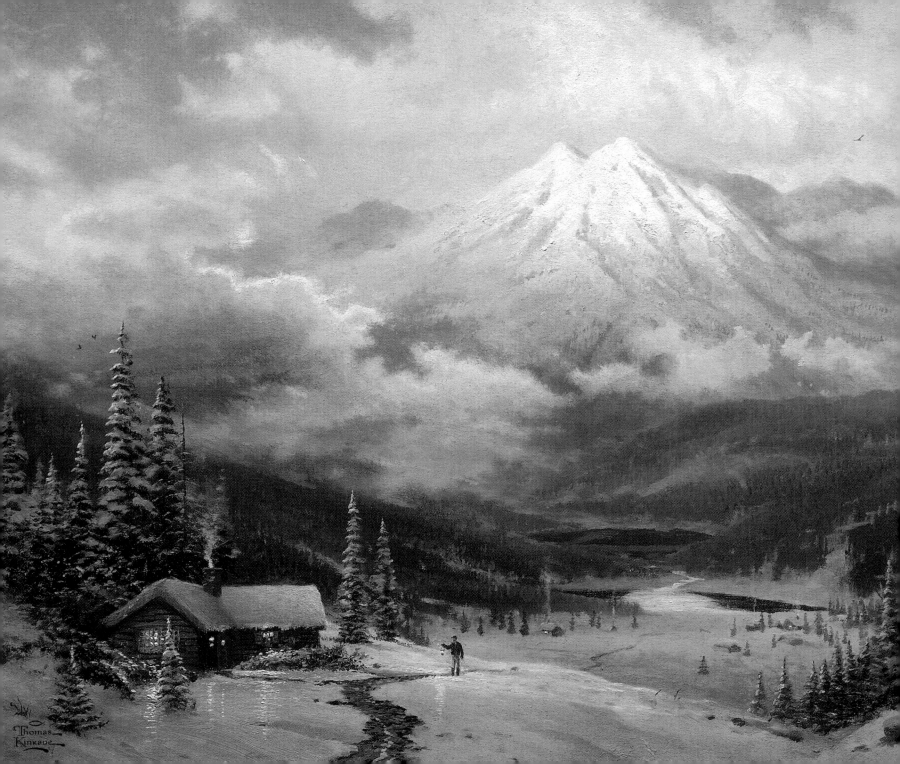

The rain and snow come down from heaven *heaven*

and stay upon the ground to water the earth,

and cause the grain to grow and to produce the seed

earth for the farmer and bread for the hungry....

You will live in joy and peace. *joy and peace*

The mountains and hills, the trees of the field—

all the world around you—will rejoice.

THE BOOK OF ISAIAH *rejoice*

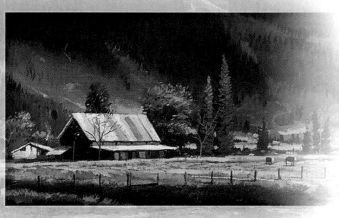

seasons

Summer and winter and springtime and harvest,

Sun, moon and stars in their courses above,

Join with all nature in manifold witness,

witness

To Thy great faithfulness, mercy and love.

T. O. CHISHOLM
Great Is Thy Faithfulness

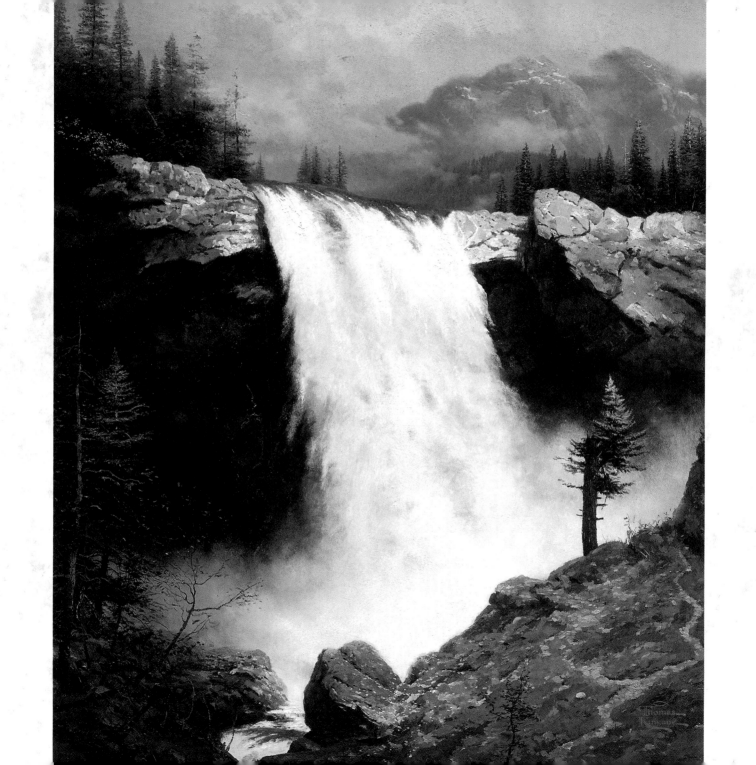

God, how great you are! You stretched out the starry curtain of the heavens,

and hollowed out the surface of the earth to form the seas.

You bound the world together so that it would never fall apart.

You spoke, and at the sound of your shout the water collected into its

vast ocean beds, and mountains rose and valleys sank to the levels you decreed.

And then you set a boundary for the seas…and streams that gush from the mountains.

They give water for all the animals to drink. There the wild donkeys quench

their thirst, and the birds nest beside the streams and sing among the branches

of the trees. The tender grass grows up at his command to feed the cattle,

and there are fruit trees, vegetables and grain for man to cultivate, and wine

to make him glad, and olive oil as lotion for his skin, and bread to give him strength.

THE BOOK OF PSALMS

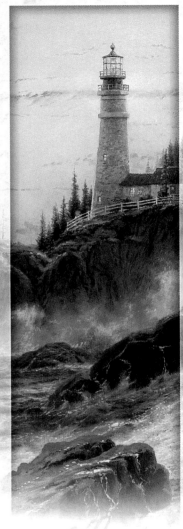

All my early lessons have in them the breath of the woods—

the fine, resinous odour of pine needles,

blended with the perfume of wild grapes.

Seated in the gracious shade of a wild tulip tree,

I learned to think that everything has a lesson and a suggestion.

The loveliness of things taught me all their use.

Indeed, everything that could hum, or buzz, or sing,

or bloom, had a part in my education—

noisy-throated frogs, little downy chickens and wildflowers,

the dogwood blossoms, meadow-violets and

budding fruit trees. I felt the bursting cotton-balls

and fingered their soft fiber and fuzzy seeds;

I felt the low soughing of the wind through the cornstalks,

the silky rustling of the long leaves....

HELEN KELLER
The Story of My Life

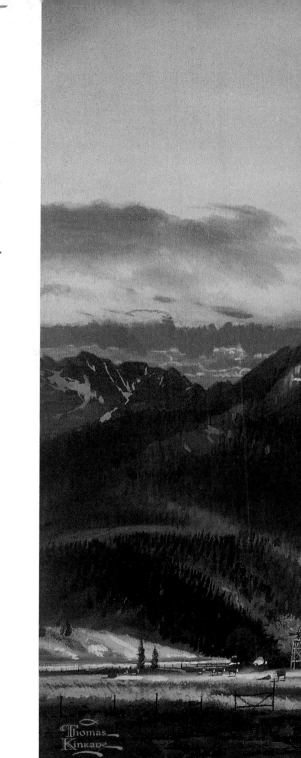

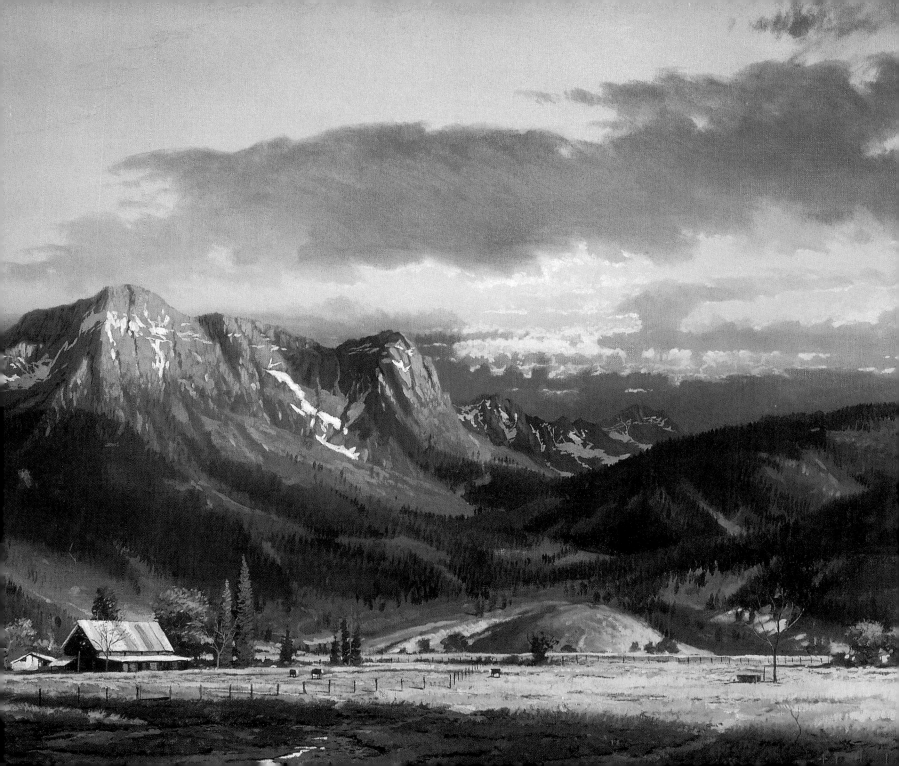

The poetry of the earth is never dead.

JOHN KEATS

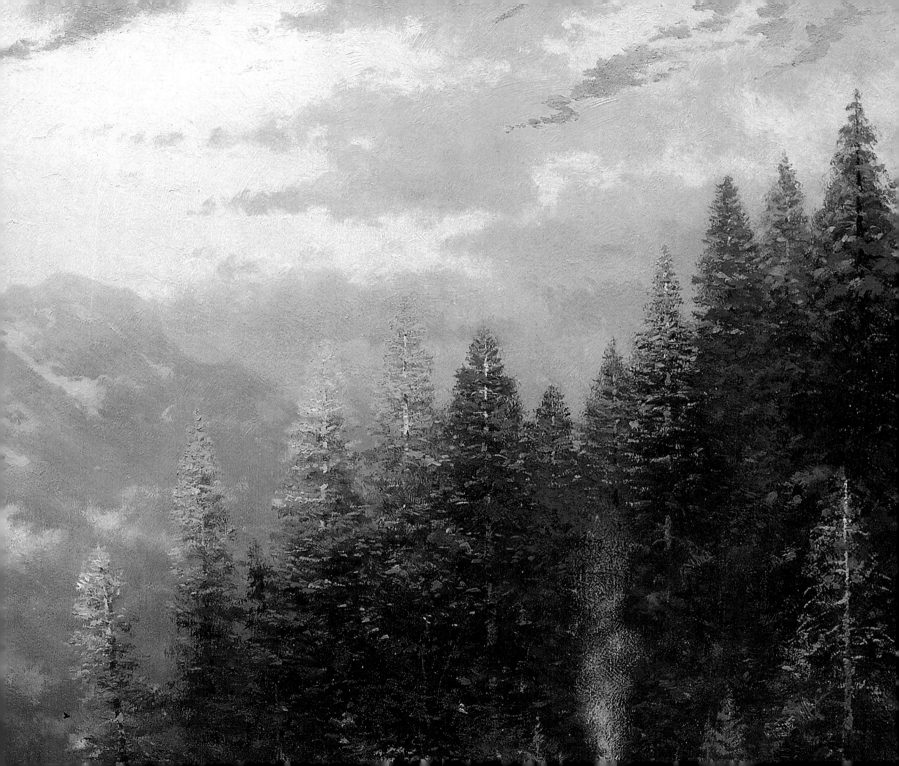

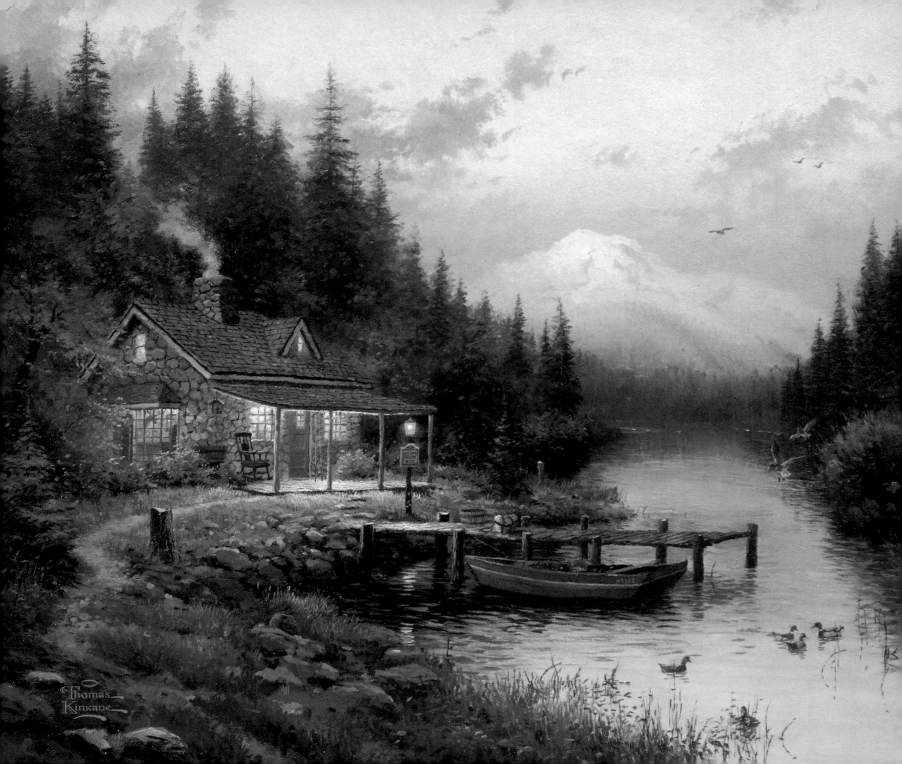

Past the spruces the lane dipped down into a little open where a log bridge spanned a brook; and then came the glory of a sunlit beechwood where the air was like transparent golden wine, and the leaves fresh and green, and the wood floor a mosaic of tremulous sunshine. Then more wild cherries, and a little valley of lissome firs, and then a hill so steep that the girls lost their breath climbing it; but when they reached the top and came out into the open the prettiest surprise of all awaited them.

Beyond were the "back fields" of the farms that ran out the upper Carmody road. Just before them, hemmed in by beeches and firs but open to the south, was a little corner and in it a garden...or what had once been a garden. A tumbledown stone dyke, overgrown with mosses and grass, surrounded it. Along the eastern side ran a row of garden cherry trees, white as a snowdrift. There were traces of old paths still and a double line of rosebushes through the middle; but all the rest of the space was a sheet of white narcissi, in their airiest, most lavish, wind-swayed bloom above the lush green grasses.

"Oh how perfectly lovely!" three of the girls cried.

Anne only gazed in eloquent silence.

LUCY MAUD MONTGOMERY
Anne of Avonlea

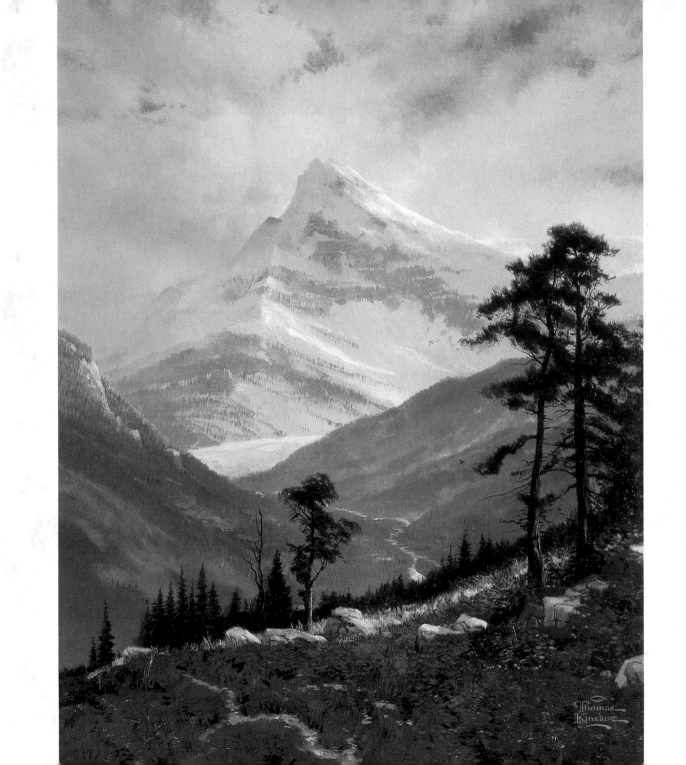

It was the month of May.

The mountain brooks, swollen by the melting snow of spring,

leaped down from every height to the valley.

Bright and warm lay the sunshine on the Alp,

which grew greener day by day.

The last lingering snowdrift sunk away,

and from out the fresh new grass the little early flowers peeped joyously,

opening hourly to the sun's quickening rays.

The merry spring breezes rustled through their new array.

High above all,

the great eagle spread wide his majestic wings against the blue,

cloud-flecked sky, and golden sunflames sought out and dried

each lingering trace of winter's frost,

and spread a warm mantle abroad over the wide Alp.

JOHANNA SPYRI
Heidi

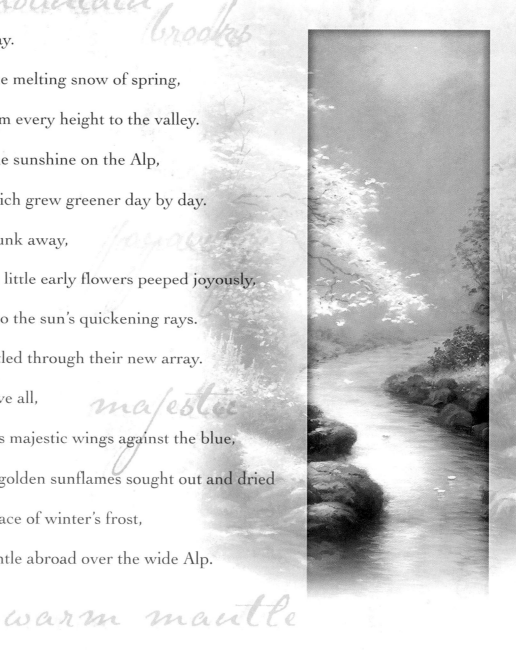

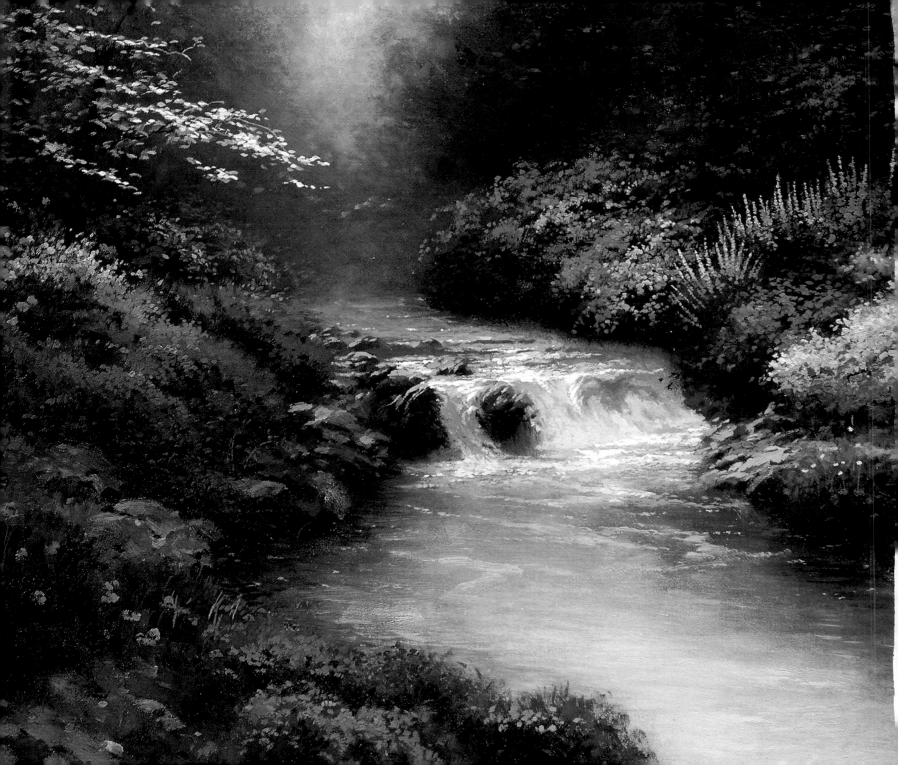

I think that I cannot preserve my health and spirits,

unless I spend four hours a day at least—

and it is commonly more than that—

sauntering through the woods and over the hills and fields,

absolutely free from all worldly engagements.

HENRY DAVID THOREAU
Walking

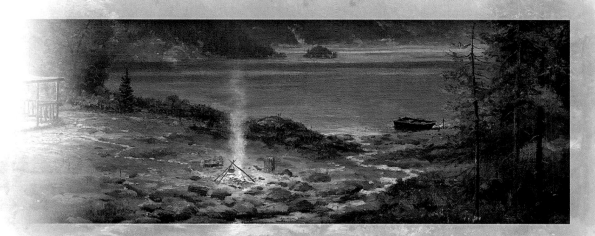

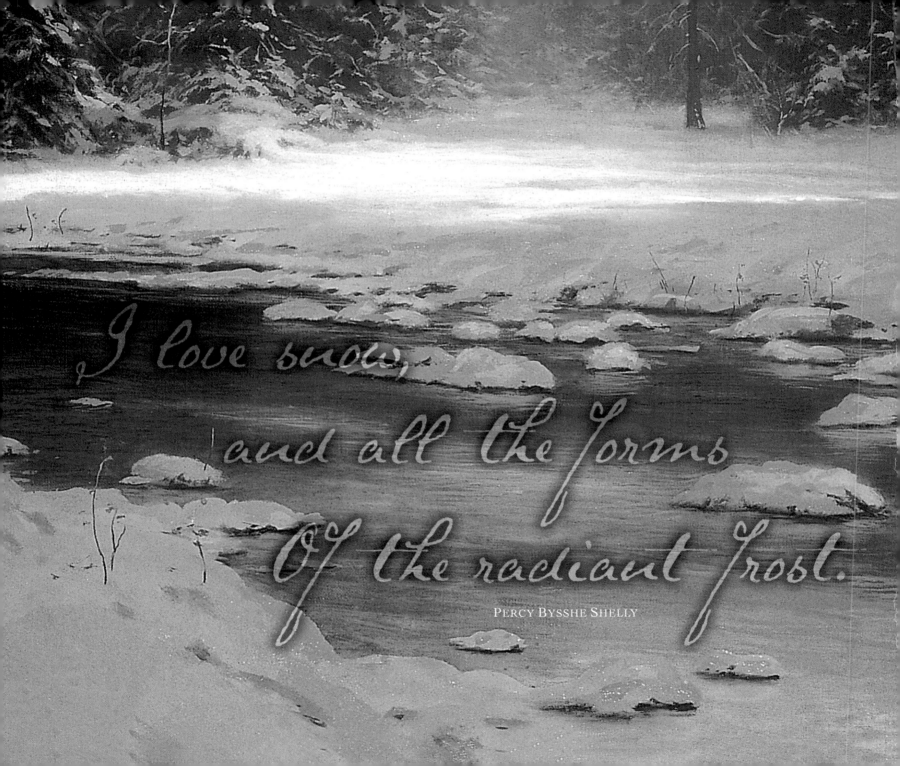

I love snow,
and all the forms
Of the radiant Frost.

Percy Bysshe Shelly

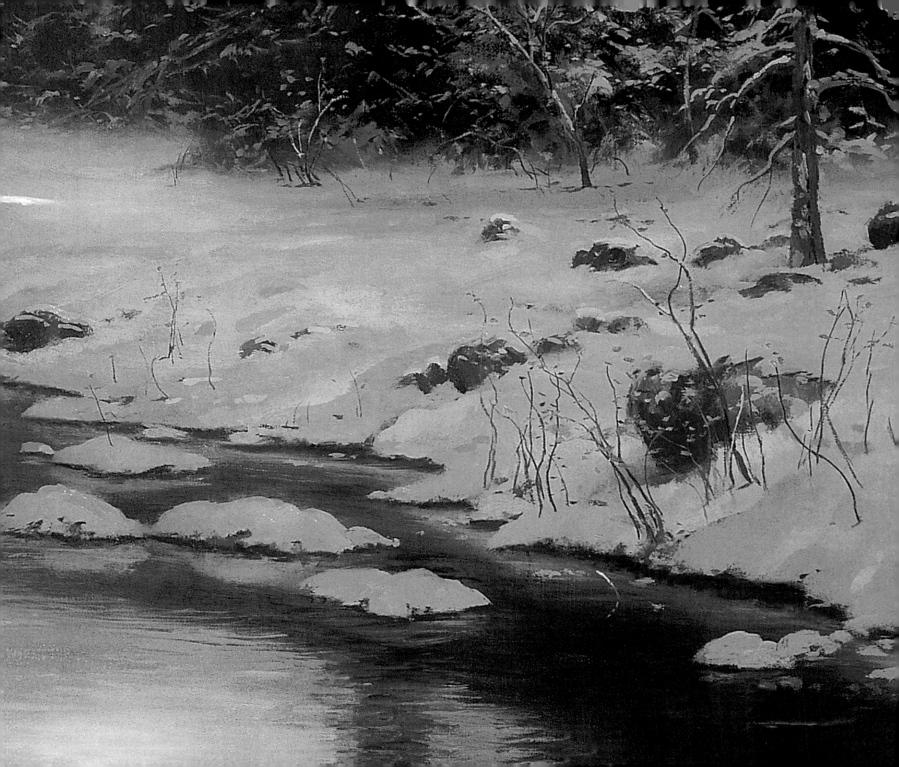

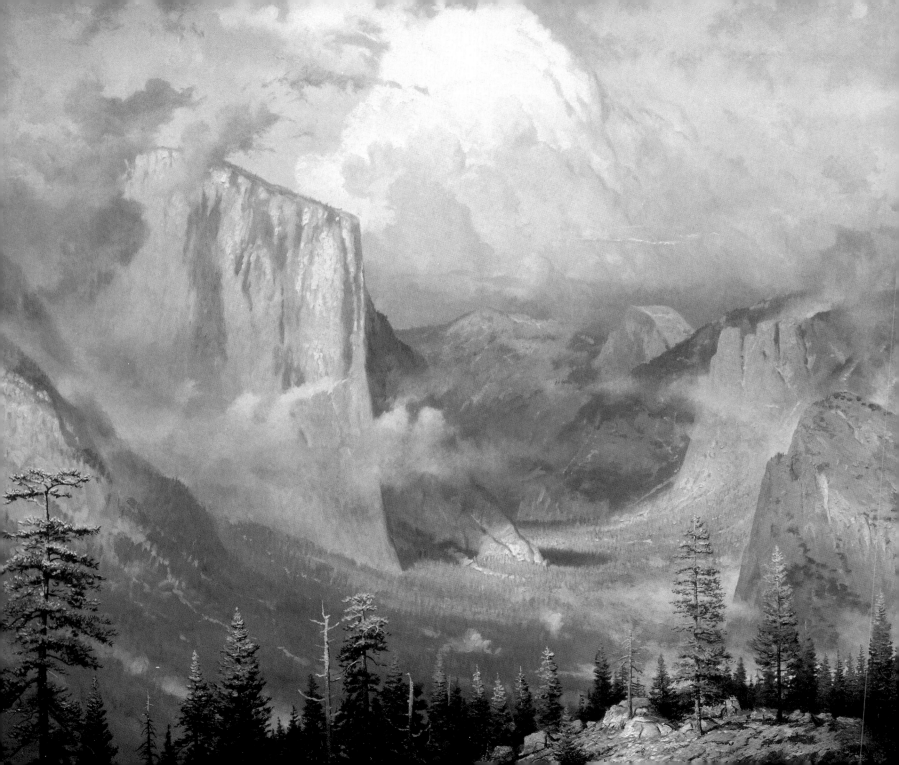

To the body and mind which have been

body and mind

cramped by noxious work or company,

nature is medicinal and restores their tone.

The tradesman, the attorney comes out of

the din and craft of the street

and sees the sky and the woods, *sky*

and is a man again.

In their eternal calm, he finds himself.

The health of the eye seems to demand a horizon.

We are never tired,

so long as we can see far enough.

RALPH WALDO EMERSON
Nature

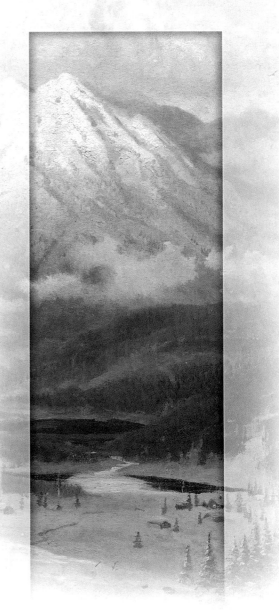

I love the summer evening

When the sun has left the west,

And when upon the wood-crowned hill

The golden clouds still rest.

The light breeze sweeps the unmown grass,

Refreshing, sweet, and cool,

And shadows from the birch trees pass

Upon the surface still as glass

Of the shallow meadow-pool.

Beside it in the running brook

The flowering rushes wave,

And in the waters cool and bright

Their rosy clusters lave;

The dewy grass beneath your feet,

The calm blue sky above,

The wildflowers bright beneath the hedge,

All whisper now of love.

Author Unknown

Thomas Kinkade

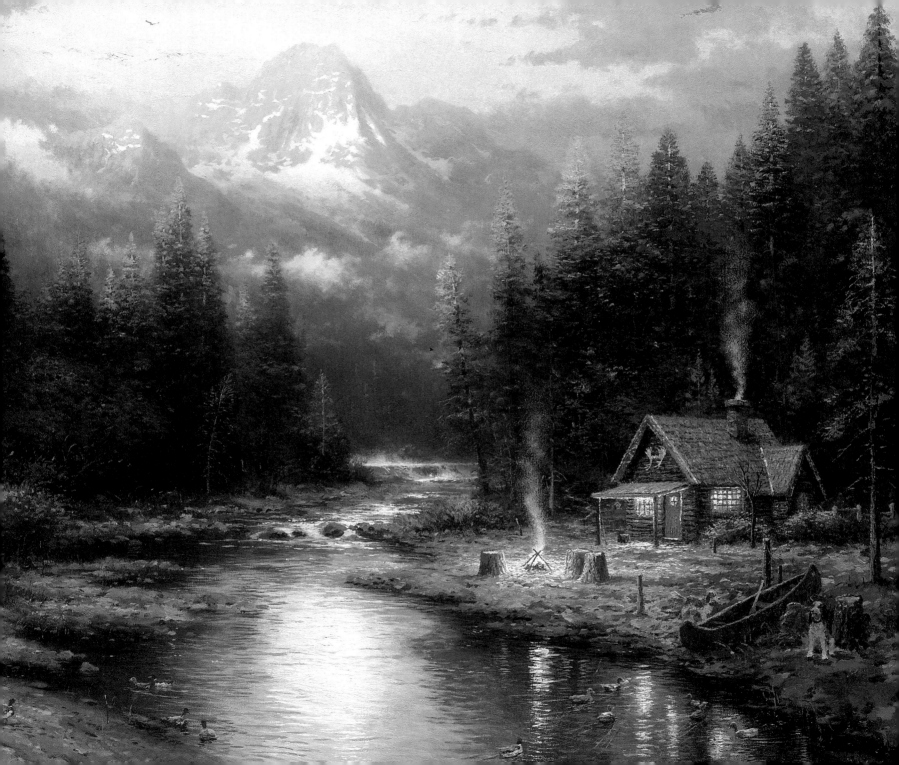

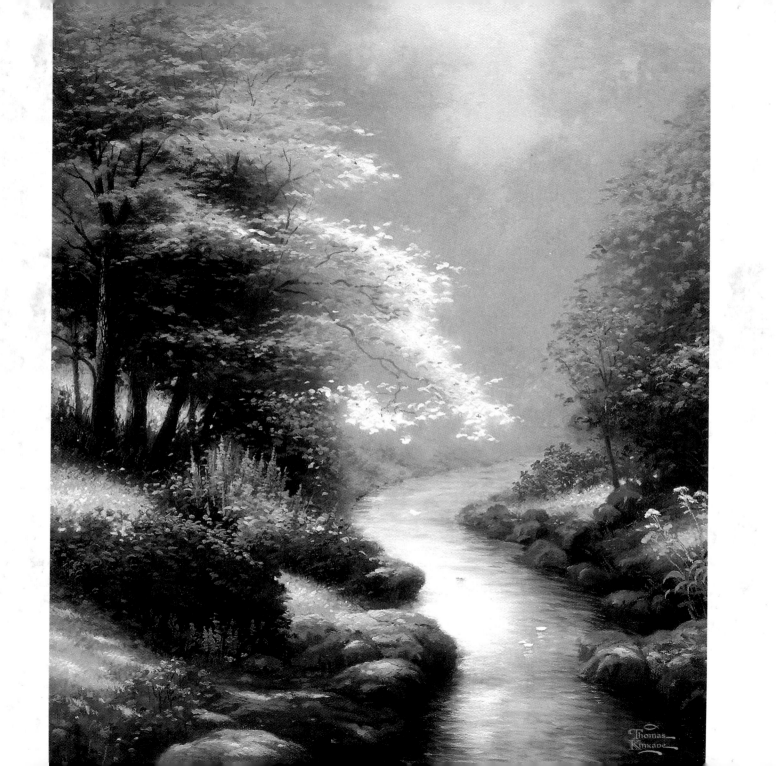

There's a path that leads to Nowhere
In a meadow that I know,
Where an inland river rises
And the stream is still and slow;
There it wanders under willows
And beneath the silver green
Of the birches' silent shadows
Where the early violets lean.

Other pathways lead to Somewhere,
But the one I love so well
Has no end and no beginning—
Just the beauty of the dell,
Just the windflowers and the lilies,
Yellow striped as adder's tongue,
Seem to satisfy my pathway
As it winds their sweets among.

There I go to meet the Springtime,
When the meadow is aglow,
Marigolds amid the marshes,
And the stream is still and slow;

There I find my fair oasis,
And with carefree feet I tread,
For the pathway leads to Nowhere,
And the blue is overhead.

All the ways that lead to Somewhere
Echo with the hurrying feet
Of the Struggling and the Striving,
But the way I find so sweet
Bids me dream and bids me linger—
Joy and Beauty are its goal;
On that path that leads to Nowhere
I have sometimes found my soul.

CORINNE ROOSEVELT ROBINSON

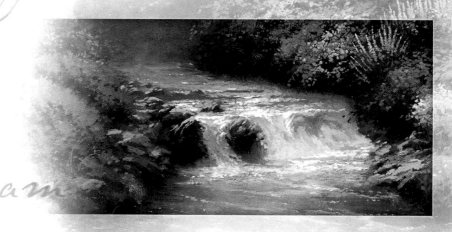

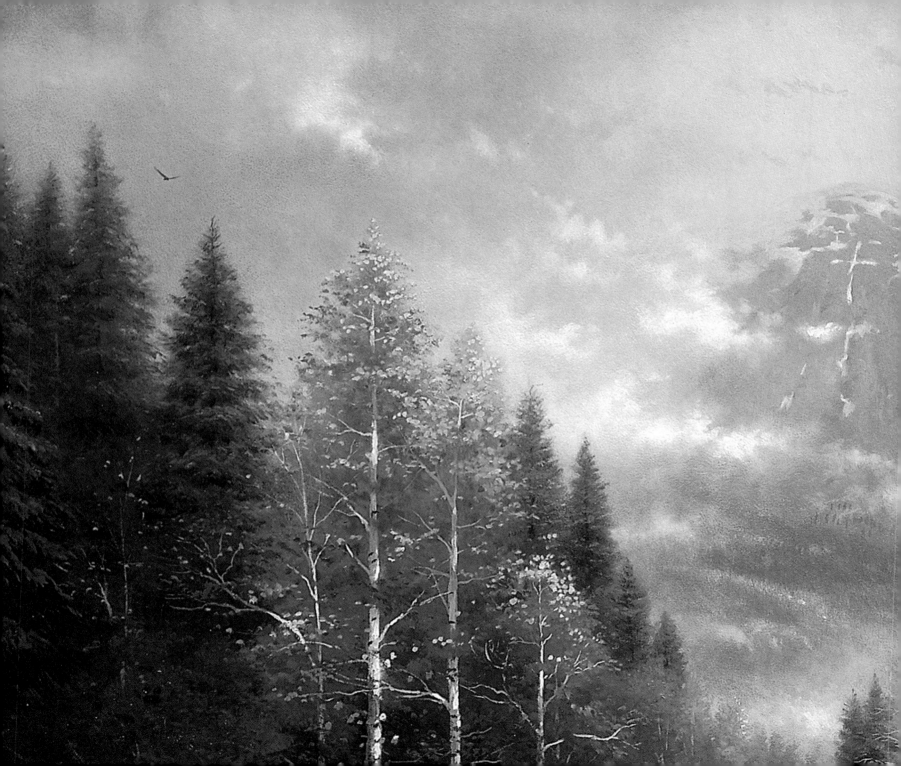

Oh, good gigantic smile o'
the brown old earth,
This autumn morning!

ROBERT BROWNING

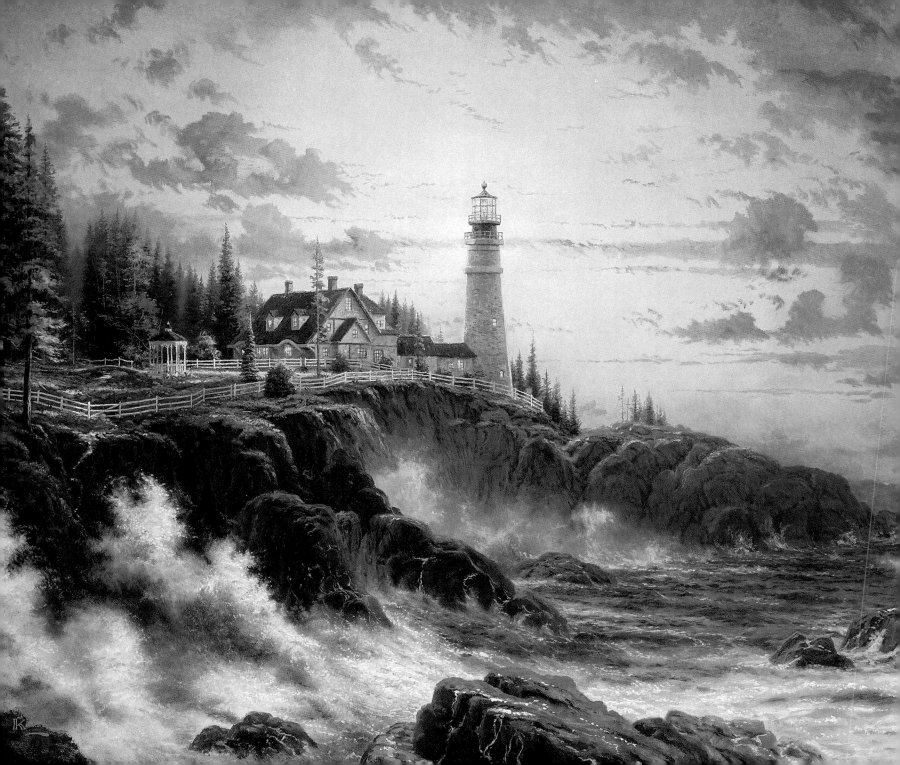

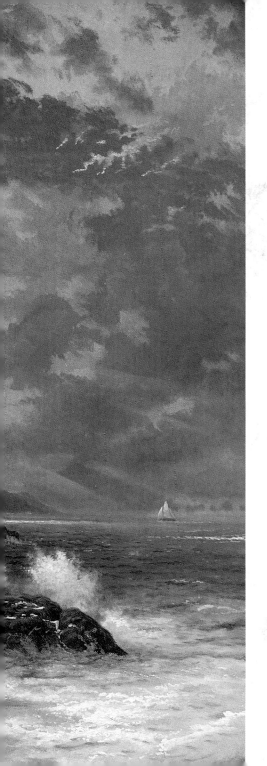

I have made friends with the sea;

 it has taught me a great deal.

 There is a kind of inspiration in the sea.

When one listens to its never-ceasing murmur afar out there,

 always sounding at midnight and mid-day,

 one's soul goes out to meet Eternity....

LUCY MAUD MONTGOMERY
Along the Shore

There before me lies the mighty ocean,

 teeming with life of every kind,

 both great and small.

 And look! See the ships!

And over there, the whale you made to play in the sea....

THE BOOK OF PSALMS

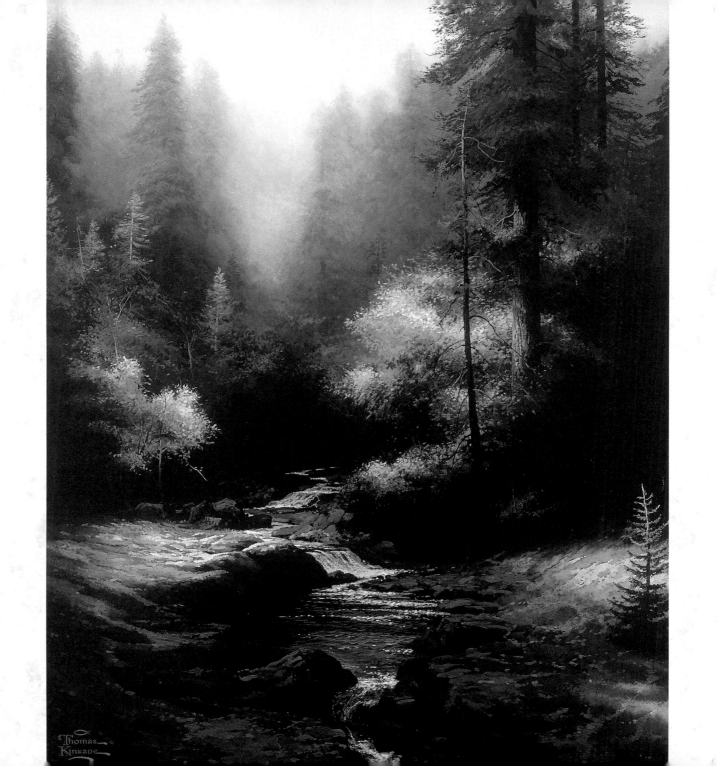

Oh where have you been all the day

That you have been so long away?

Oh, I have been a woodland child,

And walked alone in places wild,

Bright eyes peered at me everywhere,

And voices filled the evening air;

All sounds of furred and feathered things,

The footfall soft, the whir of wings.

Oh, I have seen grey squirrels play

At hide-and-seek the live-long day;

And baby rabbits full of fun

Poked out their noses in the sun,

And, unafraid, played there with me

In that still place of greenery.

A thousand secrets I have heard

From every lovely feathered bird;

The little red and yellow leaves

Danced around me in the autumn breeze,

In merry frolic to and fro,

As if they would not let me go.

How can I stay in this full town,

When those far woods are green and brown?

Dorothy Baker

Paintings